How Not to Be a Basic Peasant

How Not to Be a Basic Peasant

A Medieval Bard's Guide to Living Your Best Life

Kristen Mulrooney
Illustrated by Robert Altbauer

RUNNING PRESS
PHILADELPHIA

Text copyright © 2025 by Running Press
Interior and cover illustrations copyright © 2025 by Robert Altbauer
Cover copyright © 2025 by Hachette Book Group, Inc.

Hachette Book Group supports the right to free expression and the value of copyright. The purpose of copyright is to encourage writers and artists to produce the creative works that enrich our culture.

The scanning, uploading, and distribution of this book without permission is a theft of the author's intellectual property. If you would like permission to use material from the book (other than for review purposes), please contact permissions@hbgusa.com. Thank you for your support of the author's rights.

Running Press
Hachette Book Group
1290 Avenue of the Americas, New York, NY 10104
www.runningpress.com
@Running_Press

First Edition: March 2025

Published by Running Press, an imprint of Hachette Book Group, Inc.
The Running Press name and logo are trademarks of Hachette Book Group, Inc.

The Hachette Speakers Bureau provides a wide range of authors for speaking events. To find out more, go to www.hachettespeakersbureau.com or email HachetteSpeakers@hbgusa.com.

Running Press books may be purchased in bulk for business, educational, or promotional use. For more information, please contact your local bookseller or the Hachette Book Group Special Markets Department at Special.Markets@hbgusa.com.

The publisher is not responsible for websites (or their content)
that are not owned by the publisher.

Print book cover and interior design by Tanvi Baghele

Library of Congress Cataloging-in-Publication Data
Names: Mulrooney, Kristen, author. | Altbauer, Robert, illustrator.
Title: How not to be a basic peasant : a medieval bard's guide to living your best life / Kristen Mulrooney ; illustrated by Robert Altbauer.
Description: First edition. | Philadelphia : Running Press, 2025.
Identifiers: LCCN 2024025758 (print) | LCCN 2024025759 (ebook) | ISBN 9780762487936 (hardcover) | ISBN 9780762487943 (ebook)
Subjects: LCSH: Middle Ages—Humor. | Peasants—Humor. | Self-actualization (Psychology)—Humor. | LCGFT: Humor.
Classification: LCC PN6231.M48 M85 2025 (print) | LCC PN6231.M48 (ebook) |
DDC 940.1002/07—dc23/eng/20240626
LC record available at https://lccn.loc.gov/2024025758
LC ebook record available at https://lccn.loc.gov/2024025759

ISBNs: 978-0-7624-8793-6 (hardcover); 978-0-7624-8794-3 (ebook)

Printed in China

APS

10 9 8 7 6 5 4 3 2 1

Other Titles from the Bard

*Men Are from One Celestial Body, Women
Are from a Different Celestial Body*

The 7 Habits of Highly Effective Nuns

How to Win Duels and Decimate People

Declutter Your Black Bile

The Secret (Hint: It's Bathing)

Contents

ix	INTRODUCTION
1	AT HOME IN THE VILLAGE
25	KNIGHT LIFE
57	CAREER GOALS
79	TREAT THYSELF!
111	AND NOW I FARE THEE WELL . . .
115	ACKNOWLEDGMENTS
116	ABOUT THE AUTHOR

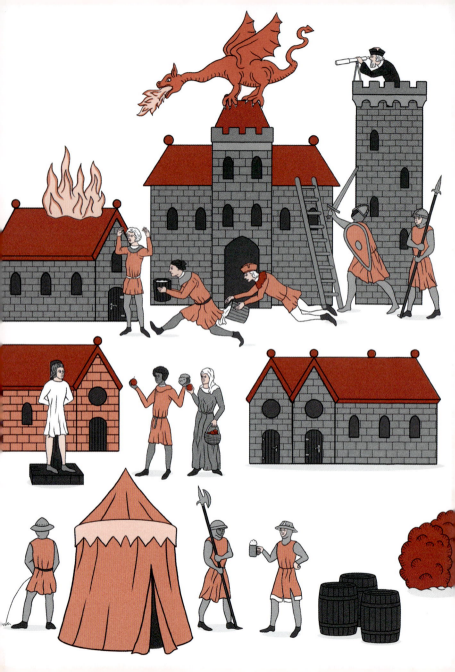

Introduction

INTRODUCTION

ark, peasants! I'm going to ask you to do something. Find the nearest reflective surface, maybe a small pond or a murky puddle on the side of the road, and take a good look at yourself.

Do you like what you see?

If the answer is no, it's time to reevaluate your basic peasant life and start working toward becoming your best and most authentic self. So often we heed to society, the church, or our esteemed Royal Highness. It's easy to lose yourself in the fray. For example, maybe you're a woman who feels confident in a dress that shows your wrists, but you keep getting thrown in the dungeon for baring such tempting skin. Or maybe you're a man whose passion is poetry, but nobody ever taught you to read or write because you're more valuable tending to your lord's beanstalks.

This guide will teach you to use your own virtues to pull yourself out of the run-of-the-mill peasant life, no magic or

divination required. By following my tried-and-true advice, you will elevate every facet of your life. You will transform socially by learning how not to act a fool during a night out at the tavern. You will dominate your work life and maximize every opportunity that comes your way. You will find tips for creating a clean and beautiful home life free of diseased rats and excrement. And most importantly, you will find encouragement for tending to your self-care, because the most important person in your world is YOU (and the king, of course—if anyone asks, His Royal Highness is number one!).

Fare thee well as you embark on this journey to becoming more than just a basic peasant.

At Home in the Village

Living your best serf life

Truth be told, peasants spend most of their days toiling away at home. As such, you want your home to be a place that sparks joy. This is not always easy—if you dream of living in the big city where the wealthy and royal saunter about like privileged peacocks, living in the pits of poverty is going to spark anything *but* joy. However, there are many ways to find satisfaction in the place you have chosen—or been destined—to plant your roots.

The most important part of your home life is, of course, the actual space in which you rest your weary head at night. After a long day of work, you come home and sink into your cot, ready to scroll the rest of the night away as you read through the latest parchments. Here you'll find suggestions for turning even the dirtiest old hovel into the castle you deserve. Creature comforts abound in this chapter. You'll learn how to use what you already have and turn your home into a place of opulence.

It is not just your home you must be a master of. It takes a village to supply everything you need for your cozy, comfy lifestyle. Let yourself be known at the markets. Converse, woo, canoodle—do what you must to put yourself in the

favor of people who have what you want. Buy a round at the tavern if you have an extra pence. Help thy neighbor when they need it. When someone mentions your name, you want others to say "That gent? I WORSHIP that dereworthy gent."

Read along for tips on how to be That Gent in your village.

BARD TIP:

Do not judge your own life based on the lives of others. When you see a painting of someone's immaculate castle, remember you're only seeing it at its best angle—all the clutter has been pushed just off-canvas.

The Life-Changing Magic of Tidying Up Your One-Room Cruck House

J ust because you're a peasant does not mean you have to give in to a slovenly lifestyle. A few quick habitual changes and a couple of stylish flourishes are all you need to turn your one-room cruck house from a shack into a majestic palace, albeit a majestic palace in which you allow your cow to sleep at night. Give some of these ideas a try and see which ones work for you. The goal here is to unlock your personal sense of serenity.

1. **Declutter your cruck house, declutter your life.** Living in a one-room cruck house has its disadvantages—mainly that space is limited. Before you can begin re-envisioning your space, you need to be able to see it. Start by decluttering. Throwing away the excess you have accumulated will give you a rebirth, a sense of new beginnings. Then you can start with a blank slate and begin making the place your own. To declutter, cut your belongings down to only what you need:

- One pallet of sleeping hay per person
- One set of stoneware dishes per person
- Two sets of clothing per person
- One tether post for your cow

2. Write up a cleaning schedule. Tackling a full one-room cruck house cleaning job can be overwhelming and when the task ahead seems too onerous, it is difficult to find the motivation to get started. Break up your weekly cleaning into smaller, more manageable tasks. Assign a chore to each day. Your schedule may look something like this:

Monday: Use a broom to clear out all the vermin and rat families.

Tuesday: Sweep the room clean of dust and dirt and any vermin and rat families who have returned overnight.

Wednesday: Remove cobwebs from the four corners of the room.

Thursday: Wipe down all surfaces, including the one window and the thin board you use as a table.

Friday: Get a bucket and a rag and attack the corner of the room where you keep the waste bucket.

Everyday tasks: Quick cleanups should be done every day, like shoveling out any accidents left by the cow while you were sleeping.

AT HOME IN THE VILLAGE

3. Everything in its place. Invest in proper organizational baskets for your storage needs. You do not want to mix up your wolf poison with your rat poison. You don't want to mix either of your poisons up with your foodstuffs. Keep each of these things in designated baskets to ensure there are no deadly mishaps.

4. Add stylish flourishes to make the place your own. Now that your one-room cruck house is fresh and spotless, you can start filling the space with calming decor that reflects your personality. Put some curtains you made from your old togas over the window. Light some wax candles. Have you ever thought about adding wallpaper? Nailing up an old piece of parchment paper from the butcher's is a utile yet fashionable way to keep the winds from blowing through the holes in the walls. Just be careful that your cow does not eat any of your wax candles, for it could loosen her bowels.

7

The most important thing in keeping your one-room cruck house clean and uncluttered is to not hold your things too dear. After all, things are just things. You can always replace your butcher's wallpaper next month when you purchase a pound of ham hocks. A cow is just a cow, although we do recommend you continue bringing her in at night, lest she be eaten by a wolf or wander off to pasture. And we can promise, you *will* see the rats and the vermin again someday.

AT HOME IN THE VILLAGE

How to Be Village-Minded

One must understand that for a village to prosper, it takes, well, a village. You know you're supposed to love thy neighbor, but loving thy neighbor isn't always enough. Take an active role in contributing to your village and helping to maintain a safe, clean, and happy place to keep one's home.

There are many ways you can perform civic duties. For instance, you must keep the walk in front of your home free of excrement. Of course, it's easiest to dump your bucket of excrement right out the front door, but it is unneighborly to make your fellow villagers sidestep your dung when they are traveling to the market.

9

Additionally, you may provide some humanitarian assistance by also shoveling the excrement from your neighbor's walk, especially if you have elderly neighbors who are thirty-five years of age or older. Indeed, it would be kind of them to find somewhere else to dump their bucket of excrement, but remember the street paths are a common space and it benefits the whole village to keep them clean and walkable.

Lastly, if you see a pile of animal dung along your route, shovel it off to the side of the street so that other passersby may walk without fear of stepping in it. I know, I know, it is not your dung and thus the onus is not on you to shovel it, but bear in mind that horses and stray dogs lack the need and physical means required to shovel their own dung.

To conclude, if you want to be a community-minded individual, simply always be shoveling excrement. After all, it takes a village.

AT HOME IN THE VILLAGE

Attending Local Events

I f your goal is to make a name for yourself in society, you must be seen. Showing up for local events is one way to build a reputation as a man- or woman-about-town, but alas, showing up will not always be enough. To be seen, you must create a spectacle. Self-promotion feels uncomfortable at first, but soon you will learn that there are benefits to be reaped from sowing the seeds of your own reputation. Thus, you must find innovative ways to command the spotlight wherever you go.

Jousting tournaments: Just because you are not a valiant knight competing for honor does not mean you can't make this exciting event about you. Use this as an opportunity to show your wit with a funny sign about the competitors. Include a play on words or a double entendre, and before you know it, talk of your witty sign will be spreading amongst the crowd.

Yelling at pigeons in the town square: Nobody likes stray pigeons! They get in the way, make too much noise, and leave droppings on everything from your house to your head. Be the hero the people need and go yell at those pigeons. Will it make you appear unhinged? Perchance. Will it make the pigeons scatter? Indubitably. Will it catch the attention of the other villagers, who will begin to

HOW NOT TO BE A BASIC PEASANT

whisper about the hero who comes and makes all the pigeons disappear? Absolutely. Be the hero the people need.

Church services: Attending mass at the church is a requirement of course, so go on and make the most out of it. During hymnals, walk up to the front of the church to perform a solo. Do not ask permission. Assuming the aura of one who is supposed to be there will confuse the people in charge—everyone will assume that someone else gave you the encouragement. Once in front of the congregation, sing loudly until you have drowned out the other voices. Do not worry about singing well; unreasonable volume should suffice. People will be intrigued, or alarmed, and afterward they will be wondering about the identity of the new troubadour.

BARD TIP:

It is impolite to stare at someone who has been locked in the pillory. Go on and give the perpetrator a kick or a tickle if you must, but then be on your way. There is no need to stop and stare and make the poor sack feel more uncomfortable than he already is, locked up there and covered in insults and rotted onions.

JOAN OF ARC'S GRAPHIC TUNICS

Not everyone has the chance to give a motivational speech before running into battle. If you spend most of your time off the battlefields, speak your truth with Joan of Arc's graphic tunics. These tunics are made with high-quality linen and adorned with bold, catchy phrases. Show your love for your favorite city, announce your support for women, or simply tell the world who *you* really are.

USE CODE 0DARC30 FOR 30% OFF YOUR FIRST PURCHASE.

Village faires: We are sure you can see the pattern by now. The key to success is setting yourself apart from the crowd. There is no such thing as bad ballyhoo. Get people talking about you by any means possible. A faire is rife with opportunity to do something so absurd, so ridiculous, that the other villagers will be talking about you for days, weeks, months! Enter a sporting competition, such as an archery exhibition, and injure someone. Gamble with dice or play a game of blindman's bluff and get caught up in a cheating scandal. Visit the feast and challenge yourself to a pie-eating contest as a crowd forms to cheer you on until you vomit. These are all excellent ways to get attention, positive or otherwise, and to keep people talking about you for days. (If necessary, please read "How to Survive If Your Life Has Been Canceled" on page 75.)

Quiz: Tell Us Your Favorite Color and We'll Tell You How You Die

As everyone knows, there are only seven colors—white, yellow, red, green, blue, purple, and black—and we will not entertain the idea of any others. We use these seven colors to convey messages in our clothing, flags, and coats of arms. Scholars have even examined these colors to decode their meanings and have determined that a beloved hue can reveal more than you think. Choose which of the seven colors you favor and read on to see how you shall meet your demise.

WHITE

White symbolizes virtue and indicates one has an innocent nature, like that of a newborn lamb. Most likely, you are free of sin and spend your days doing good for others. You heavenly creature, you.

You will die of: dysentery. Surprised? Do not be. We've already discussed the streets being literal open sewers. No matter how pious one is, nobody is safe from the perils of violent diarrhea. We'd avoid rank-smelling meat if we were you.

YELLOW

This shade brings to mind the warmth of the sun or a blooming marigold. More importantly, it's the color of gold and thus the color of wealth. A fondness for yellow suggests a penchant for greed and a pursuit of the coin.

You will die of: stab wounds. When the need for money is stronger than the law, you'd better watch out for greedy paws. Some happy dagger will find you on the streets and take you for all you're worth.

RED

Lovers of red, beware, for it is the shade of hostility—and of blood. Your love of crimson suggests a proclivity for violence. If you have passion for red, you often find yourself in scrapes with other villagers, especially after one tankard of ale turns into six or seven.

You will die of: old age. We know, life can be unpredictable.

GREEN

Green tones tend to be soothing as they evoke feelings of the natural world. If you're drawn to green tones, you have a love for the outdoors and enjoy spending time among the grass and the trees, breathing in the cleansing air and the aromas of earth.

You will die of: poisoning. Maybe accidental, maybe intentional. One way or another, you'll cross paths with an organic compound that ends up being toxic to your body. We wouldn't accept any food or drink from your enemies if we were you.

BLUE

If it is blue that catches your eye, you must know it is the color worn on the robes of the Blessed Mother. Blue musters feelings of tranquility and a sense of calm, just as you do when you walk peacefully into any room.

You will die of: uncontrollable dancing. The cause of uncontrollable dancing is yet unknown, but one can assume it is brought on by either demonic possession or convulsions caused by a fungal disease that grows in rye flour. Your guess is as good as ours. Either way, your

AT HOME IN THE VILLAGE

peaceful movements shall unexpectedly be replaced with dancing feet, and you will dance for days on end, for as long as it takes for you to merrily pass away.

PURPLE

Purple is known as the color of royalty and wields feelings of power and ambition. Lilac, lavender, amethyst, violet, and plum—all purples indicate an inclination to rule. You see your future clearly in your mind's eye, and you see yourself seated upon a royal throne.

You will die of: the plague. I mean, odds are.

BLACK

Black is the color of the most valiant knights! You have gone to battle. You have faced the strongest warriors in the land with only a sword in your hand. You have dedicated your life to defend the lord and lady of your manor. You must die a hero's death, right?

You will die of: a cow pushing you into the stream. 'Tis a bit on the embarrassing side, and uncanny for sure, but certainly not unheard of. It has happened at least twice. At *least*. The irony here is that a fair maiden could probably survive this one, but in all your heavy armor, you'll sink to the bottom like a boulder.

19

How to Make Your Own Iced Caudle

F iscal responsibility is always in style, and even if you're making as much as seven pence a year, you want to stretch every pence as far as you can. Why pay thrice the price for your favorite drink when you can make it yourself at home? If you start making your own iced caudle, the money you save could help you buy your way out of peasantry in a couple of decades—*if* God blesses you with that long of a life. Here's a recipe for homemade iced caudle.

INGREDIENTS (TO TASTE, OR IN WHATEVER QUANTITIES YOUR PEASANT WAGE CAN AFFORD)

Wine	Egg yolks
Wheat starch	A bag of stones
Raisins	Salt
Honey	Sugar
Saffron	Ginger

AT HOME IN THE VILLAGE

Step 1: Mix the wine, wheat starch, raisins, honey, and saffron in a cauldron, then set the mixture over an open flame to boil.

Step 2: Stir in the egg yolks to thicken the liquid. Once the caudle has met your desired consistency, set aside to cool.

Step 3: Proceed to the village and choose three of the strongest men in the land. Together, you must gather tools and supplies.

Step 4: Trek to the highest peak in the land.

Step 5: Once you have reached the ice-capped peak of the mountain, use an ax to chop off a chunk of ice. Not too small, because you want to have plenty of ice to chill your caudle. Not too big, because you still need to carry it down an entire mountain and any unnecessary weight could render the trip perilous.

Step 6: Pack the ice in the wooden crate you built specifically for this errand. The crate should be lined tightly with straw and sawdust to keep your ice chunk insulated during the trek back to the village.

Step 7: Like pallbearers carrying a rich oak coffin, each of you should lift a side of the crate, bearing its weight evenly. Take a moment to pray for safe returns, then begin your journey back down the mountain.

HOW NOT TO BE A BASIC PEASANT

Step 8: Oh no, a bear! Hide inside a hollow log and take care not to make a peep, even as one of your mates gets eaten. Be sure not to hold the crate of ice too close to your warm body while you hide, lest ye melt the precious ice chunk. After the bear has finished breaking his fast, check to see if any of the man's carcass remains. If so, remove two rocks from your bag of stones and place them upon his lifeless eyelids so he may rest in eternal peace.

Step 9: Now that you have one less man to carry the ice chunk down the mountain, you will need to fashion an apparatus out of tree limbs and vines to carry the crate. Make haste. A nice chilled drink awaits you at home.

AT HOME IN THE VILLAGE

Step 10: Continue down the mountain.

Step 11: Another bear! Repeat steps 8–10.

Step 12: You have made it to the base of the mountain. All should be smooth sailing from here on out.

Step 13: Except you encounter a poisonous snake. The deadly creature sinks its devil teeth into your friend's ankle. You must get home quickly! Because of the ice, but also so you can get your friend to a healer.

Step 14: Once you and your remaining strong man arrive back at the village, stop at the homes of the other two men to notify the families of their untimely deaths. Be quick, for the ice shall not last forever in your homemade ice box.

Step 15: Back at your own home, chisel the ice chunk into small cubes. Pour some caudle in a large mug and add the cubes of ice. Give it a little shake to quicken the chilling process.

Step 16: Receive word that the last remaining friend from your trek has perished from his snakebite. May he rest in peace.

Step 17: Sprinkle with salt, sugar, and ginger for a wee zip of flavor. Delish!

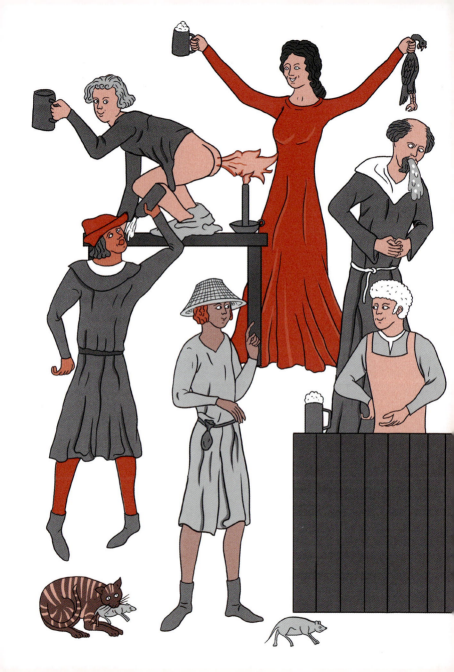

Knight Life

How to paint the town red with the charm of a noble

After a grueling week of plowing the fields, even peasants deserve to let loose with their fellow villagers. Now is the time to sow your wild oats. Indulge thyself in some feasting and merriment! Buy a round of ales at the local tavern! Lace up your dancing boots and go banquet crashing!

"But Bard," perchance you wonder, "what if I make an utter boor of myself?"

Indeed, the night is rife with missteps and a wrong turn on the wheel of fortune could leave you perceived as a basic peasant. What if you go out in high-waisted pantaloons only to learn that the high waist is so fifth century? What if you order a buffoon's ale and not the craft mead of a connoisseur? What if you look like a steed's backside when you dance? Lest the other village folk dub thee a total stamp-crab, behold these expert tips for maximizing your social prowess. By the end of this chapter, you shall look, strut, and dance like the royalty you know you are.

BARD TIP:

Do Not Gawk at Celebrities. Even if you glimpse Richard the Lionheart in the flesh, don't be a peekgoose about it. Never ask a celeb to sit for a self-portrait with you. If it is a souvenir you seek, be grateful if they deign to spit at your feet. Celebrities are just regular people—regular people with the power to have you boiled to death if you peeve them.

Get Thine Ass on the Dance Floor

Nothing is quite so unappealing as a banquet-goer who lurks along the outskirts of the festivities like moss growing on a wall. A banquet is an opportunity to put your best dancing feet forward and show the village that you have the moves. If you were not born with the gift of rhythm and do not feel you can ad-lib a dance step, practice these honored dance moves before the next rendezvous.

THE CAROLE

Every peasant must know the carole if they want to pull off being savvy on the dance floor. This one is quite simple, a step that only a dolt could screw up. For this step, dancers hold hands and move circlewise, toward the left, around an object. This dance can be performed by all women or alternating men and women.

THE BRANLE

Once you have mastered the carole, you can attempt the more advanced branle. Begin the same way as you would with the carole. Hold hands with your fellow dancers and start stepping circlewise to the left—then halt! Now,

step circlewise to the *right*. This complicated extra element may take some practice, so do attempt this in the privacy of your own home before busting it out in the chamber. If you would like to add your own unique flair to this synchronized routine, you can wow the other dancers by clapping your hands or snapping your fingers. They will not know what hit them.

THE ALMAIN

Now things are about to get sultry as we move on to the almain, a couple's dance. If you have come to a ball to meet an eligible young knight or lady-in-waiting, you will want to find yourself an almain partner. The almain is slow and sensual—quite the right dance to get you in the mood for romance. You will want to follow these steps correctly so as not to look like a goof in front of a potential mate.

First, face your partner and join hands. Step to their right and then step back into your original position, then repeat on their left side. With hands still joined, circle each other while keeping your eyes locked, for the eyes are the window to the soul. Now face the same direction and skip together in a ring. Do you feel how sensual that is? At this point, your loins will be burning with lust from the sensuality of this jig.

HOW NOT TO BE A BASIC PEASANT

Now that you have the steps for some basic dances down pat, you can begin to embellish with your own dance moves. Close your eyes. Let your body feel the melody of the hurdy-gurdy. Then when you are one with the rhythm, let the music take control.

- Grab a partner and awe the crowd with a toe tap.
- Show off your flexibility with a barrel roll.
- Secretly choreograph a routine and break into a flash mob. (To avoid confusion and potential fatalities, hold flash mob rehearsals in a part of the village separate from where the angry mob is convening.)

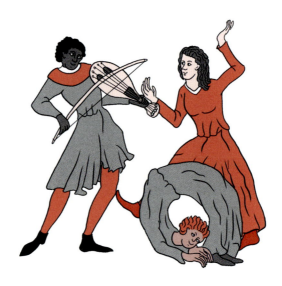

BARD TIP:

Never dance upon someone who does not want to be danced upon. Be mindful to leave plenty of room for the Holy Ghost, for two reasons. One, a true lady or gentleman would not be so aggressive in seizing a dance partner. Rather, they would extend a polite hand and ask if it would please prospective partner to dance. Two, sinful dancing is reason enough for God to smite thee with a bolt of lightning.

Medieval Style Guide

IN: Chain mail—but as *fashion*.

'Tis giving chivalry. 'Tis giving valor. 'Tis giving "watch me storm the castle to rescue the damsel who holds my heart." 'Tis soldering hot.

OUT: A knight's helmet . . . but as *fashion*.

This one feels a bit desperate, dearling. On the bright side, if you keep the visor down, nary a soul will know it's you under there. Quite cringe.

IN: Braids.

Our favorite queen, Matilda of Flanders, has been spotted rocking her signature braids when she's out in public. Put your own royal spin on the look by pinning the braids in a circle around your head like a makeshift crown. Huzzah, queen!

OUT: Tonsures.

This monk-style 'do was cute for a minute, but we are over it. Whilst the tonsure was undoubtedly a good way to keep the nits at bay, real ones know that beauty is pain, so grow out those locks, long and lush. Yes, beauty is pain indeed—and it can be rather itchy.

IN: Tailored garments.

For a more fashion-forward approach, try sewing your garments so they assume the same shape as your body. The reason behind this new style is a movement toward appreciating the human body as art. Sew some shapely sleeves into your tunic so others can see you have arms. Cinch a belt around your middle to show off your waist. This new silhouette will set you apart as an individual and may help people recognize you on the street.

OUT: Dirty chemises.

If you plan to jump on the tailored garment fad, it is time to get rid of your dirty old chemise that, up until now, has been sufficient to don underneath your loose tunic. Find some clean linens that fit snugly underneath your new garments and burn the dirty old underthings for warmth.

IN: Leggings and riding boots.

Nothing is more attractive than a man in black leggings and riding boots. This timeless style is sleek and formfitting, while practical and comfortable enough to allow a man to go about his daily errands. I avow with confidence that the leggings-and–riding boots combo is one look that nobody could ever call "basic."

OUT: Togas.

Togas have been out since the 200s. If these are still taking up space in your washroom, it's time to repurpose them. Perhaps you can sew them into a pair of leggings or maybe into a set of curtains to spruce up your home.

RICHARD II'S FOAMLESS MEAD

"Off with its head!" Get more bang for your shilling with Richard II's Foamless Mead. This honey wine pours smooth so your tankard is filled with more drink and less suds.

Seven Deadly Gaffes

Beware committing any of these seven cardinal faux pas, for they shall lead to the eternal death of your social life.

Forgetting to send a note of condolence.

It is never too late to send a note of condolence to someone who has lost a family member to the hold of heaven. So often, when too much time has passed, we prefer not to call attention to our own uncouth behavior in not sending our sympathies promptly. A message of thoughts and prayers will always be held dear, so if you know how to write, jot down a quick note like "So sorry to hear about the bear incident, perhaps soon you can come over to mine for a nice cup of iced caudle?" or something of the like.

Letting someone struggle to remember your name when they have clearly forgotten it.

If you make someone's acquaintance for the second time and they appear to forget your name, help your kinsman

out. Remind them, "It is I, [your name and occupation]." This will swiftly save the person from feeling shame and assert your power in the dynamic. *Note: Do not try this with the king or any other noble. They do not care who you are and will stomp you under their poulaines like the dung beetle that you are.*

Going into the gory details when someone asks, "How are you?"

If someone asks how you fare, the only response you should give is "I fare well!" The question was a polite query asked out of social necessity and did not require an honest response. Casual acquaintances do not care to be burdened with stories of your troubles. Nobody wants to hear that your weevils are worse than ever or that your goat has begun giving sour milk. Just say, "I fare well. And yourself?" and be done with it.

Asking someone how they got the plague.

Do not ask people how they contracted the plague. That information is between a person and their barber-surgeon. Asking such a question carries an implication that one has brought the plague on oneself, and it may bring them shame to admit they likely caught it when they stumbled into a rat's nest after a particularly rampageous night at the alehouse.

37

HOW NOT TO BE A BASIC PEASANT

Paying attention to something other than your company.

'Tis rude to ignore company by staring at a gadget or page of written word. If you are consorting with friends, put away your compass or sundial and in its stead engage with your neighbors. Strike up a philosophical debate, or even ask them a thought-provoking question about themselves. Avoid heavy topics, like sickness, the king's latest beheadings, or any witnessings of the wrath of God. Stick to lighter topics that are fun and that can help you get to know the person better. Perhaps ask about their family (unless their family is ailing, or has recently been beheaded by the king, or has succumbed to the wrath of God in previous days). Even better, try talking about the weather. "Say, we could use a little bit of rain to avoid a famine, don't you think?"

Not knowing how to receive a compliment.

Become skilled in receiving compliments. Never respond in kind with a compliment, because it will come across as insincere and forced. If someone at the market says, "Your injuries are healing up nicely after that boar attack," do not say, "And yours as well," especially if it is not true. One always knows when their boar bites are not looking quite their best. Saying, "Thank you," and offering a small bow will suffice.

Gossiping.

Only the most basic of peasants would catch themselves perpetuating rumors from the gossip mill. Spreading rumors is uncouth and ungodly and will make you appear petty. However, if you can confirm the rumors to be true, let them spread like wildfire (and wildfire will spread fast if we do not get some rain soon). Information is the key to a just world, and transparency will keep everyone in line.

BARD TIP:

Small talk is an art and you must hone your craft before chatting someone up. Whatever conversational pot you choose to stir, please do not relay the plot of a story you have just read—nobody wants to be held hostage by your secondhand account, and you may be deemed a bore.

Proper Conduct in the Tavern

We asked barkeeps what behaviors make a good bar patron. Behold these simple rules for being a proper bar patron who always gets an ale in a timely manner.

- Know what you want to drink before the barkeep approaches to take your order. Other people are waiting to be served, you know, and they will grow more impatient with every moment you and your nose of wax hems and haws over "ale or beer?"

- On that note, avoid elaborate concoctions. The barkeep doesn't want to waste his time mixing lavender or apples into your beer, you old cumber-world.

- Say please and thank you. You are not a lord and the barkeep isn't your serf. He is a man providing you good service, so be gracious.

- Drink responsibly. The tavern owner does not care to wipe your vomit off his floorboards at the end of the night. Having to do so will surely have you banished from the premises.

- Do not monopolize the barmaids. They are there to serve you of course, but they are not there to serve *only you*.

HOW NOT TO BE A BASIC PEASANT

- Do not reach across the bar for your drink. 'Tis a surefire way to lose a limb.

- Tip! If you can afford an ale at the tavern, you can afford to throw down an extra farthing of appreciation. Show some gratitude and the draughts will flow.

CESARE BORGIA FOR ELEMENTAL TEA

Having someone over for tea? Be sure to stock up on Elemental Tea*! Not only does this hot drink look, smell, and taste just like tea, it also promotes gut health by means of clearing out the bowels. Your visitors will thank you for your hospitality once you nefariously bid them farewell and send them on their merry way. Elemental Tea! The tea that comes naturally from the earth.

*DISCLAIMER: THE ELEMENT IS ARSENIC. THIS TEA SHOULD BE SERVED ONLY TO ENEMIES. SIDE EFFECTS INCLUDE VOMITING, DIARRHEA, AND AN UNTRACEABLE DEATH.

How to Earn a Five-Star Horse-Cart Rating

T hough peasants are used to hoofing it on foot when travel calls them, the best way to reach a destination is journeying by horse cart. When you traverse the land in search of goods, see if you can hitch a ride with someone who is captaining a horse cart. It is the most indulgent way to travel—sit back, be at ease, feel the wind in your hair, and breathe in the horse flatulence. Now of course you'll want to earn a name for being a top-notch passenger. Your reputation will then precede you next time you try to bum a ride, and drivers will be scrambling to host you if you need to leave the village. Follow these five tips and you'll be on your way to a five-star horse-cart rating.

Be punctual.

Try to be mindful of your driver's time. He has errands of his own to run, a job to do, and mouths to feed. Nobody wants to be the buffoon holding up the cart because he didn't get out of bed in time to embark on the trip. On a related note, hold your privy breaks to a minimum so that your driver does not have to spend all day twiddling his thumbs in the cart while you're squatting behind a mulberry bush.

Read the cart.

That is, decipher the general mood of the other passengers. Only a basic hufty-tufty would regale the party with stories of their own personal lore and their youthful accomplishments. Living off your past wild moments comes across as pathetic and sad. Likewise, if it appears that others are looking for a quiet ride, do not pepper them with questions about themselves and other humdrum small talk. On the other hand, if you have a chatty group who seem happy for the conversation, by all means do go off about the friend of a friend of an uncle who allegedly turned her husband into a common pond frog and was hung for witchcraft. Some people live and breathe for the drama.

Freshen up before your ride.

We already mentioned the horse flatulence, but that does not mean you need to make things worse. Elevate your presence by taking a bath (refer to page 90 for advice on bathing) beforehand so as not to offend with your putrid scent, you dirty hound. As an addendum, try to keep the more offensive bodily functions to yourself until you're not holding your company hostage. All in all, just present your best scents.

Do unto others as you'd have others do unto you.

The Golden Rule always applies. As the Vulgate says, we must treat others as we want to be treated. An eye for an eye, an ear for an ear, truly any body part is up for trade. Thus, try not to pick a fight in your cart over something silly, do not challenge anyone to a duel, and certainly do not maim anyone with a hidden pocket flail. Try to get to your destination with all body parts intact and belonging to their original owners.

Don't tip (the cart or otherwise).

Great news! You needn't feel pressured to tip your driver. It is understood that you have bartered for this ride already or offered some kind of compensation—why would you need to offer *more* money? It does not make sense. Indeed, the driver may be struggling to make ends meet, but surely that's not your responsibility. However . . . I did hear that other people have taken to offering a gift of a small fee to their driver as a way of showing their appreciation, but by no means will it reflect poorly on you should you choose not to do the same. Nobody would think you a cheapskate. Nay, no pressure at all.

Tips for Dealing with the Frozen Tongue Hex

You know that moment when you're trying to speak to someone and suddenly you feel as though a sorcerer in the wings has stricken you with a frozen tongue hex? Your underarms start sweating, your hands start shaking, and your tongue is rendered useless as it sits flaccid in your stupid mouth.

You will be amazed to learn that you can circumvent this wicked spell. With some practice, you too can master the counterspells necessary to shut out the devil and his frozen tongue hex.

Start with exercising your tongue. Exercising thy tongue will teach it how to work properly even in the most trying situations. We like to think of our tongue as having its own memory, so by teaching it quick songs and cantations, we are preparing it to speak. When you have some alone time, perhaps when you are tilling the fields or scrubbing the lord's privy chambers, work on mastering some tongue twisters.

A big black bug bit a big black bear.
Peter Piper pickled a pair of pesky peasants.
The sheriff shipped the slippers to the slipper chapel.
She sold doilies by the corn dolly.
Toy moat toy moat toy moat.
You know York, you need York, you need unique York.

Once your tongue is in working order, work on your presence. Find your reflective surface and practice hand gestures that make you look cool and composed, rather than erratic and unsure. Are you standing up straight? Shoulders back, spine straight as a knight's? If you appear confident, you will feel confident, and you will exude confidence to the people you are speaking to.

NOTE: Be careful as you are rehearsing your speech and posture, especially if you are of the fairer sex. If anyone sees you, they might think you have been bewitched by something even worse than the frozen tongue hex, and you will be promptly tossed in the river with your pockets full of stones.

Additionally, you would also do well to pay attention to your physical appearance. Dress in clothes that make you feel comfortable and confident in yourself. (Visit page 32 for fashion tips.)

HOW NOT TO BE A BASIC PEASANT

If you still find yourself stumbling through social interactions, be aware that you need not spend so much time talking about your old, boring self. Instead, keep the chatter going by asking your new companion questions about themself. People love answering questions about themselves!

> *What is your name?*
> *Where is your family from?*
> *What kind of Gregorian chants do you like to listen to?*

The art of the conversation is a skill just like any other art; thus it must be practiced, practiced, practiced. And until you have taught yourself to be master of your domain, you can ensure that the frozen tongue hex passes you over by wearing a satchel of thyme, sage, and boysenberry juice around your neck. Sleep surrounded by a ring of salt, just in case.

Lessons in Love and Courtship

Once you are reigning over your own life with confidence, you can move on to the next stage of your social life: courtship. You are ready to find the Tristan to your Isolde; the Robin Hood to your Maid Marian; the Jane, Anne (two), or Catherine (three) to your Henry. Of course, the pool of prospects is as small as the village, so you must set yourself on a higher steed than the rest of the suitors and suitresses.

There is an art to courting a special someone, and it starts with a single brushstroke: the clever wooing line. Try some of these lines on potential mates and see which ones stick like a thistle:

> *Are you recklessly spreading consumption throughout the village? Because you take my breath away.*
>
> *I'd scale the castle wall just to fall for you.*
>
> *Roses are red, violets are blue,*
> *it would benefit our families if I were married to you.*
>
> *If I told you your suit of armor is particularly shiny and clanky, would you hold it against me?*
>
> *Wow, you are one beautiful damsel . . .*
> *Let's get you out of "dis dress."*

Are you married?
Because I'd reform Protestantism for you.

If having eyes like limpid pools were a crime,
you would be sent straight to the rack.

Life without you is like a valiant knight's lance after shattering
against an opponent's skull: pointless.

Are you the standard punishment for murder?
Because you've got FINE written all over you.

If looks could kill,
you'd be deadlier than the Black Plague.

Were you charged with heresy?
When you fell from Heaven?

If you've snared the shrew, huzzah! But now you must tame it. Many modern romances fall to pieces because the couple fails to pledge their love to one another. Too often a torrid love affair ends with a lover being castrated and sent to the brotherhood, or even worse, with a lover's head being lopped off. Even worse than *that*, you could pull a Dante and never even find the courage to tell your Beatrice the many ways in which you love her. Relationships take work, so step to it if you want to blandish a peerless paramour into bed. Here are some of my favorite bard-approved courting techniques.

Say "I love you" in a song.

Compose your own chansons d'amour for your lover. It's easy—anyone can do it. Find a secondhand lyre and start plucking until something sounds right, and then let your words follow your heart. 'Tis most romantic to serenade your love below their window in the light of the moon, but do take care to avoid being struck with an arrow by one of their guards.

Buy your girl a girdle.

Girdles are all the rage right now. They are fashionable. They serve a practical purpose, giving women the means to carry around all of their feminine trinkets, like sewing needles and little keys. Best of all, the girdle is a symbol of a lady's relationship status, letting other eligible bachelors know she is spoken for.

Show your love through small acts of kindness.

Take it from the bard, sometimes little things go a long way. Fellows love to feel mothered, so when your man gets home, remove his shoes for him and fit him with a nice pair of dry socks. How easy is that? Also feed him, clean up after him, mend his clothes, don't talk too much, and always be obedient. Ah yes, the little things, they mean so much!

HOW NOT TO BE A BASIC PEASANT

Treat your intended to a painted casket.

Hear me out. A casket adorned with paintings of famous trysts and scenes of courtly love is the ultimate token of admiration. Now, this is a luxurious gift, so you cannot simply give it to every partner you almain with—save this for when you are ready for a betrothal. Nothing says you're serious about a relationship like bestowing upon someone the casket in which you shall someday be buried together. Until then, your lover can store their trinkets (sewing needles, little keys, et cetera) within. And they say romance is dead!

BARD TIP:

Never send double pigeons. In the event that you have begun correspondence with a potential romantic mate, never double pigeon. When you send a pigeon and receive no response, it is easy to let your mind wander to possible reasons why. Was your letter destroyed in a storm? Has your mate fallen ill? Has your pigeon fallen ill? But you must show restraint and never, ever double pigeon. You will appear desperate.

Career Goals

HOW NOT TO BE A BASIC PEASANT

Making the most of your unpaid apprenticeship

I f there's one thing a peasant needs to feel satisfied, it's a challenging and fulfilling career in a field they love, whether it be the cabbage fields or the barley fields.

Actually, the one thing they need is clean drinking water and a fresh source of protein that is unlikely to cause disease, but second to that is a fulfilling job that pays well. How then does a peasant stand out in the workplace?

Where do you see yourself in five years? Perhaps you imagine yourself rising to the top of the industry as the most reputable fishmonger in the village. Maybe you envision a future in the arts and you dream to one day sculpt the king out of stone. You may simply be working for the money and set a goal of making eight pence annually.

Whatever your future may hold, do not be overwhelmed by the wealth of opportunities that lie ahead of you. This chapter will help you identify your skills and set goals that shall guide and motivate you toward success. Before you know it, you can be the top rutabaga producer in your field, soaring to a supervisor position and leaving the rest of your fellow serfs stuck on plowing duty.

BARD TIP:

Being made an offer you can't refuse hits differently when it comes from the king, so it may behoove you to tread lightly, good fellow. If the boss says to clean the privy chamber, clean it with vigor. If the boss says to jump, ask only, "How high?" If the boss orders you to send someone to the dungeon, ask only, "Shall I give him the thumbscrews or the rat torture, my liege?"

HOW NOT TO BE A BASIC PEASANT

Quiz: What's the Right Career Path for You?

A young adult venturing out into the great wide world is faced with many important decisions. The most important of them all is "What do you want to be when you grow up?" Choosing one's career path is a daunting task. What if the job you started training for when you were seven years old ends up being the wrong path for you? Fear not, for we can help. Answer the following questions and we'll tell you what career is right for you.

1. Where do you live?

 a. A manor, alongside the lord's vassals.

 b. A village, alongside peasants and villeins.

 c. A castle, alongside nobody, for you live above everyone else, figuratively speaking.

2. What kind of special skills do you hold?

 a. I am known for my courage and loyalty. I am not afraid to ride out into battle upon a noble steed.

 b. I'm a born leader. I know how to govern a group of people and get them to do what I want them to do, and I'm not afraid of laying down punishments.

CAREER GOALS

 c. I'm good with my hands: skills like kneading dough, thatching roofs, or smithing steel come naturally to me.

3. What interests you the most?

 a. Serving my lord and my land. I care most about protecting the innocent. When I am not being a hero, I like participating in competitive sport for money.

 b. Being outdoors, working on the land, and harvesting the rewards of what I've sown. Nothing is quite so rewarding as a day's hard work.

 c. Power. Like, just being as powerful as possible.

4. What are your dislikes or fears?

 a. Not being able to do whatever I want at any given moment; people telling me what to do; people not taking my threats seriously.

 b. Starving to death during the next famine.

 c. Being beheaded.

5. What does your dad do?

 a. He's a serf.

 b. He's a knight.

 c. Oh, him? He's the king, ruler of all the land.

ANSWER KEY

If you answered *a* to question #5: After a careful calculation of your answers, we've determined that the best career path for you is serfdom. Someone has to clean the lord's lavatories after all, and to do so is a skill that is passed down from generation to generation. You might even say it is in your bloodline. You should practice rising early in the morn and performing backbreaking labor until the sun sets below the horizon.

If you answered *b* to question #5: We have broken this quiz down into an exact science, ergo we are confident in our results. You are meant to someday become a knight. Your courage, commitment, and deftness with a lance will come in handy for you in the near future, sir.

If you answered *c* to question #5: We have input your answers into our algorithm and are pleased to reveal that someday you shall be king, my liege. Do whatever you want, say whatever you want, break as many rules as you would like. Something tells me you will get ahead no matter what.

Quiet Quitting

HOW TO ACT YOUR WAGE WHEN YOUR WHOLE LIFE DEPENDS ON IT. LITERALLY.

I f there's one thing that sets peasants apart from the non-peasants of the world, it's the freedom to do what they want when they want. You must find the confidence to put your foot down and do only the work you are legally bound to do. You may be employed by the lord of the land, but remember that does not mean he owns you.

Oh. Pardon me. It appears that it *does* mean he owns you. Well then! It may be in your best interest to continue doing your job, as it is your only means of appropriating food and shelter. But remember, you should not do any more than the work that is expected of you! To reclaim more personal space in your life, you must quietly step away from the extra onus that your employer has put upon thee. Hark these responsibilities that should not be a You Problem on your typical workday:

- ◆ Rescuing a damsel from the tower where she is held captive.
- ◆ Delivering a birthing ewe's lamb that got stuck halfway.
- ◆ Mending the boot of a noble who threw his boot at you.

- Sharpening the sword of a noble who has threatened to impale you next time you make eye contact with him.

- Serving lunch to the lord and his associates as though you are a common valet.

- Planning a faire to celebrate a man's day of birth.

- Wielding a quill and scroll at the meeting and making document of all that is said.

- Cleaning out the communal ice chest.

- Being a polite listening ear when someone needs to unload their problems and whinge about the boss or their home life.

- Being the emotional punching bag for the king.

- Giving a tour to visitors from a neighboring village and making sure they are comfortable in their visit.

- Ensuring that the communal pot of gruel remains full througout the day for when one of the knights needs a quick pick-me-up.

- Tallying all of the responses from townspeople who have sent a pigeon announcing their attendance at the faire you're planning.

CAREER GOALS

- Corralling all of the pigeons to the castle pigeonry so they can rest after their long flights.

- Feeding the pigeons in the pigeonry and assuring that they feel comfortable and well cared for.

- Giving a polite send-off to the pigeons as they make their way back whence they came.

- Cleaning the pigeonry, as those particular guests make quite a disgusting mess of themselves.

- Any and all pigeon duties! You are not a pigeon keep, fie!

- Collecting coins from the rest of the peasants to present to the king on his anniversary.

This list is not all-inclusive, but a mere taste of the tasks that a person might take on even though they are not being paid for it. How then do we avoid taking on these mundane chores when we are directly asked?

You must never volunteer to do a job that is not yours. "But what if I'm trying to get ahead?" you wonder. The only person who shall get ahead is his royal highness, who will always be asking for more and who will someday be looking for a scapegoat. Your best bet is to lie low and live an easy, inconspicuous life.

If someone looks you in the eye and tells you to do a job, state clearly, "My lord, I must tend to the fields today to

harvest your crops so you may feast upon what we've sown." This phrasing will remind him of the job you have set to do, while also presenting the benefit you offer.

One of two things may happen here: The lord will imagine the banquet that awaits him from the harvest you sow and he will send you on your way. Or, perhaps, he will seethe with rage that a peasant has disobeyed him and order you to the torture chambers for a visit with the Judas cradle. (For advice on surviving once your life has been canceled, refer to page 75.)

BRANDED MERCH FROM THE COUNT OF ANJOU

When life is a battlefield, branding has never been more important. Geoffrey, Count of Anjou, never fights anywhere without his custom-made shield bearing his family's coat of arms. Let your personality and your family's torrid history shine through with your own personalized coat of arms, available where heraldry items are sold.

WORKS WELL WITH OTHERS.

COMPLETES TASKS WITH SPEED AND EFFICIENCY.

POSSESSES A POSITIVE ATTITUDE.

STRONG ORGANIZATIONAL SKILLS.

EXPERIENCED IN A LEADERSHIP ROLE.

EXCELLENT NEGOTIATION SKILLS.

GENERAL SNAIL APTITUDE.

HOW TO ASK FOR A RAISE (WITHOUT BEING BEHEADED)

Quite frankly, we wouldn't recommend even trying this.

WRITING A PERFECT RÉSUMÉ

If you want to rise in status, you must develop a clear picture of your prior work experience to show prospective lords what you are capable of. This information should go on a written curriculum vitae. If "capable of writing" is not one of the skills you can list, you might use art to help present this information. Your employer will be impressed to see that you possess some of the skills depicted on the opposite page.

BARD TIP:

Find the right work–life balance. The hardest part of the workday is making it through alive. Finding a comfortable work–life balance is the key to maintaining a fine career . . . and your life. One must weigh the dangers of performing a task against the dangers of refusing to perform the task. If a rogue alligator infiltrates the castle and your lord asks you to wrestle the creature back into the moat, take a moment to jot down a quick risk analysis before you decide whether you would rather risk injury by punishment from the lord or injury by alligator teeth.

STAYING UP TO DATE WITH NEW TECHNOLOGY

At times, you may find yourself in a comfortable place in your work life. Everything is running smoothly like a well-oiled horse cart and it's easy to sail through the day on auto-helmsman. But beware, for the well-oiled machine can just as easily drive itself into a rut, and before you know it, your skills have become obsolete. It suits the medieval worker to stay up to date with all the latest inventions to prevent them from finding themself left in the dust. Perceive these latest cutting-edge inventions.

Clock: This new mechanical timekeeping device is a game changer. Get ahead of your peers by using this weight-driven machine to stay on task and on time. You no longer have to rely on the inexact science of the position of the sun or the passing of sands through an hourglass. Now if your lord says he wants you to reap the harvest by day's end, you can check your clock to see when vespers is approaching and have your wheelbarrow of turnips on his doorstep before all the other, less punctual turnip pickers.

Compass: This breakthrough navigational tool shall alter travel as we know it. Younger generations will cease to know the struggle of their innate sense of direction guiding them into a wrong turn, a mistaken interpretation of

a landmark sending them along a rough course, or the seasonal changes of a celestial body altering a once-familiar route. The magnet-based compass will aid you in orienting yourself in space so you can find your way using the four cardinal directions. The future is now!

Eyeglasses: Could it be, an invention that is both functional and a statement of fashion? This device by Italian designers gives sight to those who have lost it, whether it be to age or to carnal sin. Get ahead in your industry with a pair of glass lenses that will allow you to clearly read even the smallest written word—that is, if you know how to read. And speaking of reading, keep an eye out for the upcoming "printing press," a device that magically creates dozens upon dozens of the same written page. Though many fear that too much page time will be detrimental to human intelligence and social graces, the savvy career folk will know how to maximize the opportunity it offers.

Counterweight trebuchet: The newest model of the familiar trebuchet uses a counterweight instead of human strength to swing the arm that flings the projectile, making this device larger and more powerful than the original-generation trebuchet that came before it. In early testing, the low- to mid-priced trebuchets proved durable enough to sling dung and animal carcasses over castle walls to promote the spread of disease in enemies' homes. The higher-priced models will serve you well for launching fireballs or massive stones of up to four hundred pounds at your foes.

HOW NOT TO BE A BASIC PEASANT

Buttons: By the gods! Have you heard of *buttons*? An innovation, a true masterpiece of human invention, the button uses a round disc and a mere slot to fasten one piece of fabric securely to another. A miracle before one's eyes! While in years past, small ornamental baubles were attached to robes as a sign of wealth, new button technology will revolutionize clothing altogether. Try to imagine: a man's robe that cinches in all the right places, hugging his form to show off his manly figure. By all that is good and holy, this invention will change the world as we know it.

CAREER GOALS

How to Survive If Your Life Has Been Canceled

I t happens to the most valiant of us: an unfavorable slip of the tongue, one bad move, and suddenly you have committed a social gaffe from which there's no turning back. You have offended the wrong person and now you face the worst: you have been *canceled*. That is to say, the lord of the land has banished you or, worse, sentenced you to death. But have no fear! You can survive this. People come back from cancellation all the time. Here's what you can do, but pray thee make haste, for time, like your life, is of the essence.

First, issue an apology. Be honest, but use language that shifts the blame off you. Be passive. For instance:

- ◆ "I am so sorry about the incident at the tavern last night in which the king was called a fat-kidneyed fopdoodle." See, here you never indicate who called the king by this name.

- ◆ "The incident speaks to a person who was uneducated on the status of the king's renal organs. I have learned better, and I am still learning." Use words that suggest forward movement toward doing better.

75

- "My sincerest apologies go out to the king, his family, and anyone else who was hurt by these words." Again, no need to mention who *uttered* the words.

Now, be aware that this public penance is not going to help anything. There is still a price on your head, thus an angry mob is after you in hopes of receiving reward money for your capture, dead or alive. Your next step will be to run, run like the winds, over the fields and through the forest (see page 82 for conditioning tips). Take a moment to catch your breath by a stream and coat your entire body with mud and silt. This will keep the hounds from sniffing you out.

Keep running, for hours or for days, until you stumble upon a village. If the village is populated with many people who might recognize you, keep running until you find a village that is full of strangers. Once you arrive, hide in the pigsty until it's safe to sneak inside someone's shack and procure an old cloak. Tie the cloak around your face. Ta-da! Now you're a visitor from a foreign land. Whatever language these people speak, you do not.

CAREER GOALS

Start a new life. Now is the time to pursue the path you always dreamed of. You can be whatever you please (except a bard—that's my job). The further you stray from your previous, canceled life, the better for keeping the other villagers from making connections. This is how you will really sell your new identity. When the angry mob is searching for a tradesman with rough hands from a lifetime of hard work, they will charge straight past a chuckleheaded jester in a unitard.

Marry someone as quickly as possible and take their family name.

The person you were before? They do not exist anymore. Any family you had in your old life? Unremember them. You have thwarted untimely death and have a new life now. Maybe someday a horse cart will roll into the village, driven by someone you once knew. Maybe your eyes will meet and they'll think, *Could it be?* Do not fret, for you have covered your tracks . . . but just to be safe, when the night is dark, go find that person in the streets and stab them through the chest with their own sword. You cannot risk any loose ends.

Congratulations! You have survived being canceled. Do not panic next time you say the wrong thing. You will follow these simple steps and come back from it again. (Figuratively, at least. You must never literally come back, for an angry mob never forgets.)

77

Treat Thyself!

Self-care of the mind, body, and God-fearing soul

et's stroll through a typical peasant day.

You rise before dawn and put on your boots. You take a swig of ale to keep you hydrated through your morning chores. Backbreaking labor commences until the sun is high, at which point you stop for a dinner of pottage and bread. You go back to work for many hours until the sky is dark, and you return home for supper. Then it's off to bed. Rinse. Repeat. Day after day after day, with the only change coming with the seasons.

It's normal for peasants to live to work, but you must find a way to work to live. I'm going to let you in on a little secret that doesn't get talked about enough in the peasant world (your liege will hate me for it!): taking care of yourself is most necessary.

Taking care of yourself is the key to a long and happy life, but you do not need a mage or a mystic to cast this peace within you. Take your self-care into your own weathered hands—mayhaps even start with a nice scrub and digging all that dirt out of thy fingernails. Focus on all the little

BARD TIP:

Free yourself from toxic gossip by logging off (repel any newsmongering enemies with a battering ram).

things you can do to make yourself feel clean, whole, and pampered, even if you spend most of your waking hours shoveling all that excrement from the street and milking old sick goats.

Fifty-Minute Knight Training Circuit

Every cultured peasant knows that a fully realized person is complete in all areas of the mind, body, and soul. You must not neglect your body and all that goes into caring for it—after all, one never knows when one will have to defend oneself from an angry mob. To live a healthier lifestyle and ensure a long life, be sure to tend to your body. Our favorite new workout is the popular Knight Training Circuit.

A good vascular routine is the best thing for your overall bodily health. An ability to keep a steady pace with a regular heart pump allows the body to outrun the wrath of an angry mob. Be mindful as you run. Keep a tight core and a straight back, while leaning forward ever so slightly. Take rhythmic breaths as you run. Put your head down and go. The hypothetical angry mob will be carrying weapons and torches, which hopefully will hinder their progress.

Build your upper body strength. There are many exercises to promote the growth of your arms, shoulders, and chest. In fact, even your daily chore of carrying large stones from one point to another for various reasons will increase your upper body girth. Supplement these movements with some knight-training repetitions. Practice swinging your battle-ax around; if you do not have a battle-ax, you can use a large hammer. Repeat these movements until your arms are weak and fatigued, until they burn like the fires of hell. Soon you will find your arms bulging with the strength of an ox, and in the event you are running for your life you shall easily catapult yourself over village walls and up into the safety of a tree's canopy.

But let's not forget leg day, for if you focus only on your upper body strength, you will look foolishly disproportionate, and the other peasants will poke fun at you. They will laugh and compare your legs to those of a common hen. They will *bawk bawk* at you and make jokes about snapping your legs in half like a toothpick. Thus, be sure to add girth to your legs. Real knights work their glutes and calves with steed hops: in full armor, run and jump onto your steed without using your arms. If you don't have full body armor, you can weigh yourself down with pocket rocks and a stoneware helmet. If you don't have a steed, you can substitute a bale of hay. Perform repetitions of ten vaults in twenty-minute intervals. Before you know it, your legs will be nearly bursting with sinews of strength.

Another great form of exercise is wrestling. Get in some grappling time with your neighbors whenever you can. This builds strength, agility, and reconnaissance, for you never know when that same neighbor will turn on you, and tomorrow he might be part of the angry mob who is after your head. Wrestle with as many people as will grapple with you, as often as you can. This could extend your life by an average of four to five years.

To conclude, keep your body in perfect, god-like shape, for the pinnacle of good health is the ability to protect oneself from an angry mob.

Feast on This, Not That

One sure way to elevate your life is by changing your dietary habits. It is easy to fall into a rut of eating food that leaves you feeling heavy, groggy, and fraught with dysentery. Making just a few small, sensible changes to your diet will have you feeling better every day. Plus, smart culinary decisions can also have a positive impact on your money pouch. Behold these substitutions that will get your eating habits back on track while still allowing you to eat with the luxury of a noble.

If MEAT is what you crave:

Oh, look at Mr. Fancy Breeches over here, thinking he can eat meat for every meal. Wouldn't that be nice? The problem is hunting game is permitted only for the lord of the manor. Sure, you have your faithful cow, but you know what they say: Why eat the cow when you can squeeze milk from its udders for free? Thou wouldn't be foolish enough to eat thy best source of cheese. Behold, there is an easier way to provide your body with all the flavor it craves.

HOW NOT TO BE A BASIC PEASANT

Eat BLOOD PUDDING instead:

You do not need meat to provide you vital life nutrients! And you do not need to eat your most useful livestock either. Your cattle will hardly notice if you slice a wee nick in the back of its leg and collect a wee bit of its blood into a wee little pot. Stir it up with some oats, peas, and tasty herbs and spices, and you have an easy ten-minute meal that is rich and savory.

If a ROYAL BREAKFAST is what you crave:

If the mere sound of bacon sizzling over the fire makes your mouth water, if buttery beans and eggs make you follow your nose out of bed and straight to the stove, if a nice toasted bread is what your belly begs for, then you are seeking for a full English breakfast.

Eat POTTAGE instead:

As a peasant, you're often surviving off scraps of whatever is available to you. Bulk up your favorite food scraps in a delicious pottage. If you have some leftover bacon jelly, a handful of beans, and an extra egg, toss them in a pot with some oats and start simmering. Add other ingredients. Like honestly, just add whatever you can find. Pottage is whatever you want it to be. Got turnips? Toss in some turnips! Have a surplus of rutabagas? Throw them in! Boil it all up nice and hot until the broth, or milk, or whatever liquid base you have used is nice and thick. Voila! This is comfort food.

If WATER is what you crave:

Truly, we understand the instinctual desire, but we cannot recommend it. We've noticed a direct correlation between drinking the water and contracting certain tummy troubles, and we advise you to ignore the instinct to hydrate your body with this clear, cool, vile liquid. It may be readily available, but if you have roughly four weeks of prep time, we have a better solution for you.

Drink ALE instead:

Yes, start your day with a fresh mug of ale and keep your mug topped off throughout the day so it is always full when

HOW NOT TO BE A BASIC PEASANT

you need to quench your thirst. A brewed ale is much preferred to the dangerous water. The drink is sweet and tasty, and though it may cause a stumble or two by midday, it will keep your bowels free of demons.

If WHITE BREAD is what you crave:

Charlemagne? Is that you? You look so different without your crown and scepter and gilded robe, but surely only a man of great wealth would expect to eat white bread on the daily. No, we can't all live the epicurean white bread life, but never fear, for there are many other loaves from which you can choose.

Eat RYE BREAD instead:

We know what you're thinking. Rye bread is as basic as it gets—that is, until you know how to spruce it up. Instead of eating straight rye bread, hold it over the fire for a few moments until it develops a light brown toast. Then, spread it with a smear of mashed peas and add salt and pepper to taste. We're calling it pea toast and it's going to be all the rage next year. But wait! Before you eat, take a moment to place the pea toast in the golden light of the sun and paint a still life of it. You shall want to look back on this memory some day and share it with your friends.

If a NICE CHRISTMAS SWAN is what you crave:

Indeed the festive merrydays are a time to cook up the most elegant fowl in the land for a hearty dinner. Alas, this graceful creature is a delicacy saved for the nobles and it will not prove easy to get your peasant hands on one. Fret not! You can still find a gorgeous bird to roast on a budget.

Eat SNIPE instead:

If Jesus can feed thousands with two fish and a few loaves of bread, certainly you can find a way to divide a nice li'l snipe up for your family to celebrate his B-day. Stretch this baby bird to feed all your guests by packing in the sides: turnips, goat cheese, and peas galore! The smell of this holiday meal will have everyone's tummies rumbling (for good, not evil!).

Spa Day

Everyone deserves to treat themselves to a day of spa rituals and healing. Just because you're an impoverished peasant does not mean you can't take a day to indulge in the pleasure of self-care.

AROMATHERAPY

Fill a pot with water and sage leaves. Set the pot above an open flame to boil. Soon, your one-room cruck house will be filled with the strong herbaceous scents of the leaves. These aromas will help you relax with the assurance that evil spirits cannot enter your home.

PURIFY THE BODY BY BATHING IN A SPRING

Bathing in spiritual waters is said to have healing properties, as the water cleanses and purifies body and soul. Your little peasant village likely does not have spiritual waters, but you can make do with whatever is available to you. Take a dip in the small pond in the fields or submerge yourself in the lazy brook by the forest. Let's face it, those waters aren't exactly crystalline, but go on and take advantage with a replenishing mud mask. Soak in the purifying minerals of the element. But alas, beware of newts getting into thy crevices.

VISIT THE VILLAGE BARBER

If the wheel of fortune ever sends a few extra pennies your way, indulge in a trip to the village barber. The barber offers all of the pampering you need to feel revitalized and refreshed. Have that snaggletooth removed. Detox your body in a nice relaxing bloodletting session. You may as well even get a shave and a trim while you're there.

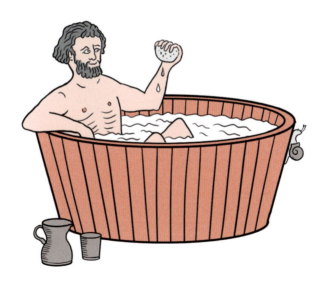

DANTE'S FIRE-AND-BRIMSTONE-SCENTED CANDLES

If you love the smell of petrichor, you'll love these waxen candles that smell of the rains of fire and brimstone. The wrath of God has never been so soothing. The extra-long wick will burn for eternity*!

*6–8 hours

Skin Care Tutorial

Oft an overlooked part of health and hygiene, skin care plays a vital role in living your best life. Though vanity is a sign of the devil, there's no reason your skin should look withered and wrinkled before you have reached the age of two score.

Introducing a basic skin care routine will help you maintain the smooth, milky complexion of a newborn princess. Start small to get yourself into a routine of caring for your skin, and then add on as you see fit.

At the end of the day, use a cleanish, damp rag to remove grime and buildup from your face. Under the layers of dirt, dust, smoke, animal waste, and blood, you will find your skin. You may have to really scrub, depending on how long that blood has been there. The skin underneath will likely be several shades lighter than the face you are used to seeing.

Always protect your skin from the sun. Nothing says "basic peasant" like skin that is gold or crimson from hours under the sun. Before you spend time in the fields, cover up with a hat. To cure skin that has already been damaged with spots, try a home remedy such as an oat-and-vinegar tincture, a wine-and-tarragon mixture, or pulverized

HOW NOT TO BE A BASIC PEASANT

ginger swirled into the blood of a hare. Truly, anything you can think of might work. Give it a try.

Before going to sleep at night, put a serum on your face to keep your skin from drying out. A mask made of honey and flower petals will keep things smooth and tight. If you do not have any handy, provide moisture to your face by rubbing it with animal fats and starches. If this all seems counterintuitive, do not worry about it. Beauty isn't always logical.

Book Talk: Feeding the Mind

While appearances are vital, keeping your mind sharp is another way to knock people off their feet. Reading literature is one way to feed your mind. Knowledge of books and plays will make any peasant seem sophisticated and cultured. Try setting a goal on New Year's Day, March 25, to read more books. Here are some recommendations for my favorite books and writers (rated out of five sickles—what else?).

THE CANTERBURY TALES BY GEOFFREY CHAUCER

The Canterbury Tales consists of a collection of tales told by a group of pilgrims on their way to Canterbury. We upgraded this from four to five sickles because of its innovative premise. It tells a narrative involving unrelated stories that are linked through the proximity of the travelers. Chaucer brings the characters to life in a way that feels personal: the Wife of Bath is simply groundbreaking, the Reeve and the Cook pop off the page, and we're pretty sure Chaucer wants the Squire. Our one qualm with this one is that it feels rather unfinished, as it ends on an ambiguous note that leaves many loose ends up to the reader to tie together.

BEOWULF BY UNKNOWN
♪♪♪

This. Poem. Is. WILD! We don't want to spoil anything, but allow us to set the scene: our hero, Beowulf, is called by the king of the Danes to come defeat the monster Grendel, who has besieged his castle. A battle ensues. This tale has everything: violence, mommy issues, dragons, and tons of alliteration. We knocked off a sickle because the poetry form felt rather shoehorned in, but we loved the epic battle of it all. We do not even know who wrote this one, but their imagination is WILD!

SIR GAWAIN AND THE GREEN KNIGHT BY UNKNOWN
♪♪♪♪

We love this chivalric romance by an unknown writer! The drama starts when Sir Gawain chops the Green Knight's head off, leaving him alive but headless. By way of a previously agreed upon deal, the Green Knight gets to deliver the same blow to Sir Gawain a year from now. The suspense in this one is to die for, not to mention the spicy turn the story takes when Sir Gawain visits the home of a lord and lady on his quest to find the Green Knight. This narrative twists in ways you could never imagine.

THE TRAVELS OF MARCO POLO BY RUSTICHELLO DA PISA AND MARCO POLO

♪♪♪

I mean, 'tis fine but it left me feeling a little underwhelmed. This collaboration with Marco Polo and Rustichello da Pisa details Polo's travels in the East. It is fantastic, cartographically speaking, but it leaves little room for romance, drama, or suspense. If you like maps, you'll love *The Travels of Marco Polo*. Otherwise, we recommend you skip to Part 4, where the wars and cannibals finally make an entrance.

NIBELUNGENLIED BY UNKNOWN

♪♪

Another poem, this one with less alliteration but longer, more complicated words. The narrative of the poem is a bit convoluted and the language rendered us utterly pitch-kettled. We might recommend this one to the German speakers, but if you are not fluent you will not be able to read these words, even if you are literate, until someone manages a translation.

LE MORTE D'ARTHUR BY SIR THOMAS MALORY
♪♪♪♪

Now this is entertainment! The story of the life and death of King Arthur is full of adventure and romance. We loved this whole cast of characters, from the forbidden love of Lancelot and Guinevere to the quirky stylings of the wizard Merlin to the brave battles of the Knights of the Round Table. With themes of love, loyalty, and some traditional medieval betrayal, this page-turner will have you burning the midnight beeswax to keep reading through the night.

DECAMERON BY GIOVANNI BOCCACCIO
♪♪♪

This book came highly recommended, but honestly the *Decameron* feels somewhat derivative of Chaucer's *Canterbury Tales*. Perhaps it was written with Chaucer in mind, as a form of devotee fiction. Alas, despite the many, many tales included in the *Decameron*, and the fact that its ending comes together more concretely than *Canterbury*, we can't help feeling like we have been there and done that already.

TREAT THYSELF!

How to Survive a Plague

King or peasant, lord or serf, there is one great power who sees us all as equals: the Black Death. The Black Death chooses its victims seemingly at random, so nobody is safe no matter their title or birthright. You are on your own to evade its fever, chills, and fatigue. But there may be ways to avoid the illness and give yourself the upper hand in surviving the plague.

1. Atone for your sins. In the event that the plague is a punishment from God, try atoning for all of your sins. Find a local priest and offer him a gift. Confess all you have done wrong. Say a hundred Hail Marys. If you do this all right and obtain His holy forgiveness, you may escape the coughs of blood.

2. On a related note, check to make sure your hose are loose enough. Anecdotally speaking, some men who have contracted the plague have worn hose that suffocate their nethers so much that they cannot kneel to pray.

HOW NOT TO BE A BASIC PEASANT

3. Find a secret water source. Search the forest for a brook or stream and start drinking from that, and *only* that. If others in the village fall ill to the plague and you do not? It is safe to believe that an enemy has poisoned the local well. Be on the lookout for other ways a foe may be trying to infect you.

4. Have you tried smoking a pipe? Healers postulate that the combination of smoke and heat can kill the minuscule impurities inside of you. Kill impurity with impurity. If you consider smoking a wretched habit, turn to some other vices, like drinking or gambling with cards and dice. No, these debaucheries will not cure you, but at least you will be making the most of your remaining days. You only live once, good friend, so you may as well put all your coins down on one last game of thimblerig. Just don't get caught cheating, or you shall risk meeting your demise with a different kind of vice.

5. Pay attention to the positioning of the stars and planets. Try to be aware of when illnesses are more prominent and notice how that relates to the celestial bodies in the sky. Smoke your pipe even harder next time the stars align in that same way.

100

TREAT THYSELF!

Though there's no way of knowing exactly how or why this ailment spreads throughout the land, killing everyone in its wake, our gut tells us that keeping a distance from our sick friends will help keep us alive. In unprecedented times such as these, how can one survive such isolation? If your village does succumb to diarrhea and swollen eggs inside the body, use these methods to keep from losing your sanity.

- Forget thy neighbor. To put it in simple terms, hoard everything you can get your hands on. A plague is a battle between the haves and the have-nots, and you want to be sure you have a bunch of stuff. Make sure you have the *most* stuff! You never know when supplies will run out and you

could be left with nothing. When you go to the market to stock up on pig livers, take them all! Even if the butcher is running low. Even if your neighbors are right behind you in line hoping to have something to feed their family. Do not let that vex you. Take it all!

- Masque up. If you have the money and means to do so, lock up in a castle with hundreds of your closest friends. A-list only. It'll be quite the affair, a masquerade with all of the wealthiest people in the land. Certainly no one and no plague could ever harm the village elite, for they are immortal. So have a ball and leave the peasants to deal with the Death outside. Just make sure none of the guests let the Black Death sneak in behind them.

TREAT THYSELF!

- Have you considered getting into breads? How about a nice sourdough? If everyone is locking themselves away for fear of catching the bubonic plague, you shall have lots of time to yourself. Sourdough and other artisanal breads are a great distraction from the unprecedented times falling to pieces around you. Rolling out the soft dough with your hands is so soothing and meditative. The aroma of fresh bread is a comfort to all! If you become burdened with too many loaves of bread, leave some outside for vagrants, but maintain a healthy distance—they may be able to spread the disease through their shifty eyes.

It can be hard to survive in these trying times. But sit tight and try to pray your way out of it, because someday doctors will figure out how to cure diseases, and the people of the world shall rejoice and do exactly as they say and we shall never fall ill again.

Quiz: What's Your Sense of Humor?

'Tis scientific fact that a person's physical and mental health status is determined by the four humors: blood, yellow bile, black bile, and phlegm. The humors are carried by the bloodstream, and as they course through your body, they breed the core passions of anger, grief, hope, and fear. An influx of any of these bodily fluids could throw your temperament into a state of disarray. Take this quiz to find which of the four humors is in excess in your body.

1. What is your favorite prank?
 a. Telling a pal that a beautiful damsel wants to kiss him, but that he must not peek. Then lead him blindfolded to a horse's backside and let him lay on a smackeroo. This one's always a hit!
 b. When an enemy is not paying attention, set his sleeves on fire. Take that!
 c. It is amusing to witness when someone passes out on the streets and someone draws a phallus on their face, but I do not want to actually be a part of it.
 d. Sometimes when someone tries to rouse me, I do not wake up, but not on purpose.

TREAT THYSELF!

2. You are served the wrong drink at the tavern. How do you react?

 a. No worries! What say you buy a round for the other patrons and you can all share a drink together? There is joy to be found even in unfortunate circumstance.

 b. You alert the barkeep and graciously accept the correct drink. You grant him a smile and accept his apology. But you shall not forget. You never forget. Someday, when he least expects it, he will pay.

 c. It's just like . . . can't anything ever go right?

 d. Ask the barkeep for a new drink. It is not that big of a deal, but when every drink may be your last, you want to make it count.

3. What's your favorite weather?

 a. A warm spring day always strikes your fancy. You love the feeling of the sun beating down on you. Flowers are blooming, the grass is dewy, and life is good.

 b. The hot dog days of summer, when the fields are burnt to a crisp and everything is dry and brown.

 c. When the chill of fall creeps in and everything starts to die. You finally feel as though something understands you.

CONT. ON NEXT PAGE

d. A cold and damp winter day. It is a good excuse to stay inside under a heavy cloak, drinking tea and blowing your nose, which is heavy as always with mucus.

4. Huzzah! You have been awarded a sack of gold coins for placing first in a jousting tournament. What is the first thing you buy?

a. A roast from the butcher, some mushrooms and vegetables and fresh fruits from the market, and the best wine you can find. You shall throw a feast for all your nearest and dearest friends!

b. A new dagger, just in case.

c. A quill pen, pot of ink, and some long scrolls of parchment paper. You will use it to write down your secrets in a diary and compose poetry that will be appreciated only long after your death.

d. Medicine.

5. Which animal would you choose as a companion?

a. A dog. Perhaps a spaniel or terrier to take hunting or hawking? On days of rest, you could frolic together in the fields. He would become your best friend.

TREAT THYSELF!

b. A snake. You would watch it slither around deceptively and you could spend hot days basking in the sun together, letting your skin dry out.

c. A crow. You like its dark nature. When you are feeling morose and harping on the state of the world, he will always agree with you.

d. An old, old tortoise. You like how he is old and does not do much and never requires much care aside from tossing him a leaf of old lettuce once in a while. It would be just the two of you, sitting in your bed, wishing it would all end.

6. What do you look like? (You must fall under one of these categories.)

a. My skin is rosy and quite pretty.
b. I am greenish with a yellow tint to my skin.
c. I have black hair and black eyes like an evil demon.
d. My hair is white like an old wizard's.

107

ANSWER KEY

If you chose mostly *a*: Your body is full of BLOOD. This is good! Blood is full of energy, making you active and social. You are pleasant to be around and enjoy living your life. Keep doing what you're doing.

If you chose mostly *b*: Your body is in excess of YELLOW BILE. Also known as choler, this fluid can be found in the gallbladder or wasteful excretions. You have an irritable nature, which is fine, but you might want to find more balance in your humors to weigh out your emotional irregularities. Be aware of your tendency toward irrational anger and outbursts. You do not want to wind up in the village jail for murder.

If you chose mostly *c*: Your body has tons of BLACK BILE. Honestly, that explains why you're always such a bummer to be around, as black bile is the source of melancholy. You'll definitely want to find some more balance in your humors. Go outside, get some sun, maybe see about getting leeched to bring some blood to the surface and some color to your pale cheeks. Just try to cheer up, will you?

If you chose mostly *d*: You have too much PHLEGM. Gross! This is the most disgusting of the humors, found in all the white and clear secretions of our body, like mucus, saliva, pus, and some others that we will not name. You are retentive, sickly, and rheumatic. Quite frankly, you should see a healer or a priest.

And Now I fare Thee Well . . .

Well, peasants! You have completed your studies and emerge fully educated in the art of living the life of a cultured being. Like a mother bird, 'tis time for this old bard to nudge you out of the nest and send you into the world.

I must acknowledge some of the people who made this possible as I conclude these generous scrolls. I extend my deepest gratitude to my dear mentor, the talented Geoffrey Chaucer. Although Geoff and I have not had the pleasure of actually meeting face-to-face, I consider him an inspiration and a kindred spirit. Someday, if he answers my letters, I hope to collaborate with him on a project.

I must bear thanks to Dante Alighieri, who broke ground with his stylistic endeavor into the vernacular. Without him, I could not have imagined writing such a forthright piece of literature in which I speak directly to the reader as though they were my friend and underling.

And to all the beautiful queens out there who have served as influences in my life of glister and gold, even when our other values may not align: Isabella of England, Eleanor of Aquitaine, and all the nicer Matildas, for even a woman of the highest nobility feels like a basic peasant at your feet.

And to you, dear reader, who has taken the first step in living a better life. At times you may refer back to this

guide as you navigate your newly refined life. Recall you are embarking on a change in lifestyle and it shall not happen overnight. Rather, you will make small changes every day and rise the next morn feeling more confident and secure in your own skin sack.

I urge you to share these readings with your basic peasant friends who would benefit from the instruction in this parchment. Share it wide, with the rapidity of the bubonic plague. I ask you to look forward to my future writing and sign up to receive my next book by pigeon as soon as the ink is dry.

Please subscribe.

About the Author

Kristen Mulrooney is a writer living in Chelmsford, Massachusetts. Her humor writing has appeared in numerous publications including the *New Yorker*, as well as McSweeney's, where she pens the column "Letters to Moms." She is the editor of humor and satire publication The Belladonna, a job that allows her to amplify the voices of funny women across the country and beyond. Kristen is the author of several pop culture–inspired books such as *Gilmore Girls: The Official Cookbook* and *Barbie IRL*. When she's not desperately trying to be funny on paper, she's at home desperately trying to be funny in real life with her beautiful, unimpressed children, wonderful husband, and beloved dog.

Acknowledgments

I'm forever grateful to the people who make it possible for me to write books.

To my editor Maria Riillo, who is full of funny ideas and valuable insights: thank you for letting me write this book! I'm so proud of our finished product.

Thank you to Brooke Preston and Fiona Taylor for taking me under your wings, and to the rest of the team at The Belladonna—you've all made me a better writer.

Thank you to the people who have been making me laugh for decades and continue to inspire me with their humor and creativity. Mark Wahl, for teaching me everything I ever needed to know about Chaucer. Joel Howe, for your swift responses when I text "quick Joel, think of a word for me."

And to my family: Thank you to my buddy Adam Mulrooney for watching movies with me to help get into the medieval mindset. Laughing with you when the bride got kicked in the chest is one of my favorite memories. Thank you, Matt, for always giving me time to write, and if the time didn't exist, for creating it, and Mattie and Greta for your patience and support. I love you all!